Judith Keller

RALPH EUGENE 55
MEATYARD

Φ

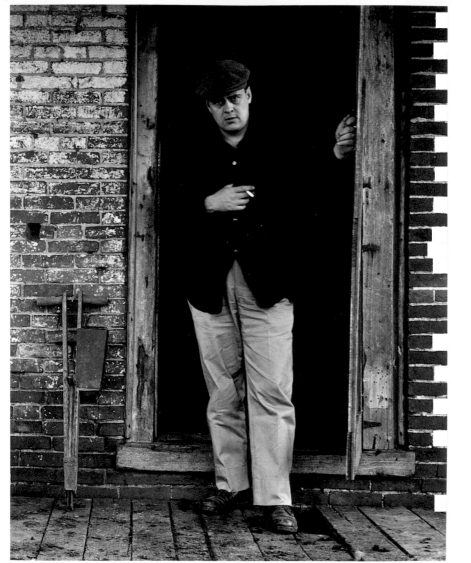

2.3

Ralph Eugene Meatyard (1925–72) was born in the town of Normal on the Illinois prairie. His father worked in real estate. Gene was raised in the small adjacent city of Bloomington, home of Illinois Wesleyan University and of the Adlai Stevensons. Indeed, during the 1940s, the Meatyard family occupied the two-storey Italianate former home of Adlai Stevenson I, while Gene attended University High (as Adlai II had done some twenty-five years before). He then spent a year at Williams College before serving with the navy in Virginia during World War II. Back in Normal, he married Madelyn McKinney and became an optician. By this time Adlai Stevenson II had become the state's governor and would soon be entering into presidential politics.

Seeking a better position in the business of grinding lenses, Meatyard moved south with his wife to another modest city suffused with history, Lexington, Kentucky. He took a nine-to-five job with the firm of Tinder-Krauss-Tinder, and they made their home below the Ohio River in a state where the Civil War was still living history. The abandoned mansion of Cassius Clay, Lexington newspaper man and avid abolitionist, would become a favourite haunt for the Northerner. Kentucky held abundant opportunities for Meatyard to explore a fascination with the past that no doubt came out of his Bloomington boyhood.

In addition to fitting spectacles, Tinder-Krauss-Tinder sold cameras and other photographic equipment. This combination of services, all directed towards helping people to see, probably derived from the amateur interests of the Tinder brothers, who were both members of the Lexington Camera Club in the 1940s. Begun in 1936 by a dermatologist from one of the city's first families, the club was founded to encourage the making and exhibiting of photographs; the University of Kentucky Art Department provided space for the monthly meetings.

As a new father, Meatyard acquired his first camera in 1950 in order to photograph his son, Michael. Developing a more serious interest in photography, he found his way to the club in 1954, also joining the Photographic Society of America and submitting prints to national exhibitions. Among the membership of the Lexington Club at the time were two important figures in Meatyard's career: Cranston Ritchie, who would become his inspiring model for the next five years, and the operator of a local hardware store, Van Deren Coke. Coke had been active in the club since he graduated from the university in 1942, and took a leading role in its pursuits, offering private classes for serious members and, apparently, stimulating them to take a personal, subjective approach to making pictures. Although he left Lexington in 1956 for the University of Indiana and a future in college teaching and museum work, Coke was an important mentor for Meatyard, helping the optician to see the artistic possibilities in photography, and including him in an exhibition for the University of Kentucky called 'Creative Photography' in 1956.

The 1950s was a conservative and prosperous decade in the United States. For the first time in twenty years a Republican had been elected president: the war hero Dwight D. Eisenhower had defeated the liberal-minded man from Illinois, Adlai Stevenson II. Winning the Cold War and raising the ideal suburban family were promoted as the sole concerns of an increasingly insular population. America's businessmen went to work fulfilling the dreams of its burgeoning households. A Memphis contractor built a chain of motels for newly mobile families like his own; a Chicago distributor of milk-shake machines decided the country needed a hamburger franchise; and suburban developers across the country mass-produced homes for America's working- and middle-class families. On the west coast Walt Disney was busy creating an empire based on

feeding American fantasies, opening Disneyland in Anaheim and premiering 'The Mickey Mouse Show' on television. The age of Disney saw the birth of the TV family sitcom. From 1952, Americans could tune in their black-and-white screens to the scripted rearing of two boys, David and Rickie, by their real parents, the actors Ozzie and Harriet, while the fictional Cleavers brought up Wally and the Beaver. 'Father Knows Best' aired first in 1954, and – for a little variety – the ever-faithful Lassie appeared weekly with Timmy and his farming family.

Gene Meatyard was a family man. He and Madelyn had three children – Michael, Christopher and Melissa – during the 1950s. They lived in a brick house in Lexington's Fairway neighbourhood on the edge of the Idle Hours Country Club and Golf Course. He went to the office each day, dressed slightly more nattily than the man in the grey flannel suit. Evenings were often spent with the Boy Scouts or at Little League. And Meatyard's wife and three young children served as models for his photography. But the art he pursued had little in common with that promoted by Walt Disney or the television networks, or, for that matter, by the important tastemaker of contemporary photography, Edward Steichen, director of the Photography Department at the Museum of Modern Art, New York.

Steichen had been mounting exhibitions at MoMA for about ten years, and his crowning achievement was the enormous and highly praised exhibition 'Family of Man' of 1955. This blockbuster presented 503 photographs drawn from sixty-eight countries, and clearly demonstrated that Steichen, under the aegis of MoMA, considered the photojournalist style of American photographers W. Eugene Smith, Robert Frank and Dorothea Lange to be the most important of the moment. The widespread attention given to Steichen's 'Family of Man' was

also an indication that by the mid-1950s photography was advancing in its struggle for acceptance as a fine art. During the same period, two galleries devoted to photography opened in New York: Helen Gee's Limelight and Roy DeCarava's A Photographer's Place. The idea of incorporating photography into the academic curriculum of art schools and university art departments was gaining popularity. Teaching was beginning to be a viable vocation for photographers who would previously have looked for work in advertising or journalism. The pictorialist style perpetuated by provincial camera clubs began to wane as galleries and colleges provided exposure for a diversity of approaches.

This was the moment at which Meatyard began to make serious photographs. In 1955 he and Van Deren Coke produced the 'Georgetown Street' series illustrating life in an African-American neighbourhood in Lexington. These pictures were shown in 1957–8 at A Photographer's Place. In the same year, DeCarava published his own story about Harlem (*The Sweet Flypaper of Life*) with Langston Hughes. During the intervening year, Meatyard and Coke attended a three-week summer workshop on photography at Indiana University in Bloomington. The instructors were Henry Holmes Smith (the organizer and a teacher at IU), Aaron Siskind (who was teaching at the Illinois Institute of Design in Chicago) and Minor White (curator and editor at George Eastman House in Rochester, New York). This seminar was the first of many that White, who would begin teaching that year at the Rochester Institute of Technology, would lead. As the head of most of the sessions offered that summer he recommended that the students critique photographs in a traditional art-historical manner, analysing their formal structure and iconographic content as well as the technique involved in their making. He encouraged them to look for multiple layers of meaning in photographic images. Like Smith and Siskind, White was a

proponent of abstraction; he believed that non-objective expression in photography could carry signs and symbols just as painting did. His teaching method involved not only the formal lessons of art-historical theory but also the technical ones of the Zone System developed by Ansel Adams for obtaining artistic prints from flawless negatives. White also referred students to readings in other fields that he felt would enhance their future work.

Among these were books on Zen Buddhism, like Eugene Herrigel's *Zen in the Art of Archery* (1953), and on theatre, such as *Acting: The First Six Lessons* by Richard Boleslavsky (first ed. 1933). White had been using Boleslavsky's writings as a model for his thinking about photography since the early 1930s. In addition, he photographed stage productions and made publicity pictures for theatre companies in Portland and San Francisco. His interest in Asian culture had begun during his years teaching at the California School of Fine Arts in San Francisco. In 1953, the year that Beat writer Jack Kerouac discovered Dwight Goddard's *A Buddhist Bible* in the San Jose Library, Walter Chappell, another photographer who believed in metaphorical camera images, introduced White to the Chinese Book of Changes, the *I Ching*. Recently published in English, this work was already influencing New York artists such as the musician John Cage. White would eventually adapt many aspects of his life to the ways of Eastern religion, and Meatyard, his student, would follow up his teachings with a vengeance, amassing an impressive library in Lexington to continue his own education in the ways of the East.

Discussion at the Bloomington workshop may also have touched on current poetry and music, since all three instructors favoured interaction with other media, and White's classes in particular stimulated talk of alternative cultural

forces. White considered himself a poet as well as a photographer. It may have been his classes that encouraged Meatyard's enthusiasm for the literature and contemporary poetry of the San Francisco Renaissance. Meatyard's library expanded in that area, too, eventually including the publications of Lawrence Ferlinghetti, Kenneth Rexroth, Michael McClure, Gary Snyder and Allen Ginsberg. Other Beat authors, such as Jack Kerouac, William Burroughs and Gregory Corso, as well as the writers admired by that circle, from Walt Whitman to Ezra Pound and William Carlos Williams, would ultimately find their way onto Meatyard's shelves.

In addition to volumes on Eastern religion, poetry, literature, history, science, mathematics, mythology, philosophy, photography and vision, Meatyard obtained as many books on art as the resources of Lexington and nearby Louisville would permit. His access to the history of art was very much limited to that reproduced, often in black and white, on the printed page. He acquired an education in art through published series such as Skira's 'Taste of Our Time' and George Braziller's 'Great American Artists' or individual surveys, the most numerous being those on the Surrealist movement. The monographs issued by the Museum of Modern Art from the mid-1940s to the mid-1960s to accompany exhibitions were also critical sources for Meatyard, particularly those published on Balthus, René Magritte and Ben Shahn. Books were a passion matched only by Meatyard's joy in making pictures and a mania for music — blues, swing and jazz.

Meatyard's interest in music began in high school. Along with the drama and chess clubs, he was a member of the school band and orchestra. His instrument was the then fashionable descendent of the concertina, the accordion. As a

young man he developed a zeal for the new music of swing and bebop. He would ultimately accumulate more than 1,000 albums on sixty-six different labels, each of which he meticulously inventoried and cross-listed, from Apollo to Victor. For his listing of the ten-inch LPs, Meatyard itemized his collection by title of sides both A and B. For 778 of his ten- and twelve-inch albums he gave each record a number and then made an alphabetical listing of every musician who performed on the disc, citing their instruments and cross-referencing them by album number. This self-assigned tedium allowed him to consult his music quickly, from alto-saxophonist Charlie Parker to lesser known performers, such as Fats Navarro (trumpet) and Bud Powell (piano), who were at one time part of Parker's Quintet. Meatyard's lists reveal a highly methodical character that strove to gain control over everything, even his passions.

This passion for African-American music, which was part of the foundation of the new Beat style emerging on both coasts, influenced the Lexington photographer's picture making in several ways. His serious attempts at abstract photography began in about 1956, shortly after the Bloomington workshop. At this time, Meatyard began to undertake different series that investigated camera work without conscious focus (the 'No-focus' series), meditation on single delicate twigs (the 'Zen Twigs' series) and the reflection of light on a moving stream. The results of the 'Light on Water' exposures can be related to the many-layered rhythms and complex sounds of jazz. And jazz was exactly what Meatyard would listen to during his lengthy annual printing sessions.

Meatyard's creation or 'authoring' of pictures went on all year, usually on Sundays. For him, the art of photography was in constructing the subject and making the exposure. Each picture was a performance, each was deliberately

conceived, and represented something about the photographer's own life. He would take his collection of county road maps and set out along Kentucky's country lanes in search of a distinguished but deserted home or a wooded site. Some, if not all, of his children would be with him, ready to serve as models if the right setting (or stage) were found. In his trunk would be props in the form of rejected dolls and doll parts, mirrors and mirror fragments, masks (some of homemade papier mâché), hangers for use in impromptu still life and sculpture and perhaps a dead bird or rubber chicken. Or he might decide to arrange objects from his refuse collection on the driveway next to his house, or visit the Lexington cemetery so that he had access to a backdrop of rough stone and disfigured monuments.

Printing, however, was a concentrated process, more in the nature of an annual ritual, that took place at home once a year. The makeshift darkroom was contrived in a bedroom. Water had to be brought in. And most of the carefully constructed lessons of Adams' Zone System, devised to help every photographer make readable negatives and then obtain prints with the full range of greys, were ignored. Meatyard worked intensely for several weeks, selecting images to be printed from the thousands of negatives created over the previous twelve months. The background music was always jazz; the proceedings were spontaneous and intuitive. The photographer's wife Madelyn was, when available, the invited critic. The approved prints sometimes contained dense blacks and only slivers of white; sometimes the surface contained every shade of grey, with stone looking exactly the colour of stone, and black being as rare as a genuine white. Inspired by Duke Ellington, Louis Armstrong or Dizzy Gillespie on the hi-fi, he managed to render beautiful, evocative prints from negatives that were often underexposed.

Among the hundreds of books of poetry in Meatyard's library was the anthology assembled by Elias Wilentz and Fred McDarrah called *The Beat Scene* (1960). Jonathan Williams, a young poet and publisher from North Carolina, was pictured in the book at a party he hosted for an opening of the Living Theatre. In addition to managing the Jargon Press, Williams travelled the country, lecturing, listening and introducing himself to America's writers. His friend, Lexington author and University of Kentucky English professor Guy Davenport, described him as 'the iconographer of poets in our time'. Although an outsider, Williams was a kindred spirit and a critical catalyst for intellectual life in Lexington. Meatyard enjoyed a stimulating friendship with him during the 1960s, which would culminate in an innovative publishing collaboration (the posthumous *The Family Album of Lucybelle Crater*, 1974). That decade, the ten years between his heart attack in 1961 and his decline from cancer in 1971, proved to be Meatyard's final opportunity to make accomplishments in his own art and to share his ideas with other artists. A growing acquaintance with Williams' friend, Guy Davenport, motivated his further investigations into both photography and literature.

Davenport, a South Carolina native and recent Harvard Ph.D., arrived in Lexington to begin teaching in 1963. He was a few years younger than Meatyard and his publishing career had just begun. A volume of poetry, *Flowers and Leaves* (1963), was in the works when he arrived. Williams' account of Davenport, opposite his picture in *Portrait Photographs* (1979), characterizes him as the most 'prodigiously talented man of letters' Williams had encountered on his American expeditions, and portrays him as 'penman, critic, writer of fictions, poet, pedagogue, ransacker of the most interesting cultures since the Old Stone Age'. Davenport's talents as poet, essayist and short-story writer were

augmented by his skills as a draughtsman and painter. His interests ranged over the globe and encompassed the history of the visual, as well as the literary, arts. His house was filled with books, those necessary for his own 'literary archaeology' and those sent to him for review. Meatyard was fascinated by this array of reading material. And he was impressed by the boundless curiosity of the academic. Davenport, for his part, was intrigued by Meatyard's photographic art and by his contented life of anonymity in Lexington. In an essay about his friend for a posthumous monograph published in 1974, Davenport wrote about what he saw as Meatyard's perplexing duality: 'He was a quiet, diffident, charming person on the surface, a known ruse of the American genius (William Carlos Williams, Marianne Moore).' And he reminisced about the group of images Meatyard had shown him when he first visited his house with Jonathan Williams in the company of filmmaker Stan Brakhage and poet Ronald Johnson: 'I remember thinking that here was a photographer who might illustrate the ghost stories of Henry James, a photographer who got many of his best effects by introducing exactly the right touch of the unusual into an authentically banal American usualness.'

Throughout the 1960s, as Meatyard was beginning to achieve increasing recognition through a series of one-man shows and magazine publications throughout America, Davenport would be Meatyard's friend and literary mentor. He was present when Meatyard met another man of letters who would become a spiritual advisor as well as an artistic colleague: Thomas Merton, a Trappist monk of French descent. Again, it was the gregarious wanderings of Jonathan Williams that made the connection. A fellow publisher at New Directions press, which had issued Merton's books since the 1940s, suggested that Williams visit him at his hermitage. Merton entered the Abbey of Gethsemani

in 1941. His life at the isolated monastery in northeastern Kentucky was devoted to silence and austerity. But he was a prolific writer. More than fifty books and numerous articles followed his first volume of poetry, *Thirty Poems*, in 1944. In the 1960s when Meatyard made his acquaintance he was reading about Eastern religions. He had access to the Dalai Lama and the Zen philosopher Daisetz Suzuki, with whose writings Meatyard was already familiar. The monk and the photographer talked about the history and practice of Zen and exchanged black ink *sumi-e* paintings and abstract photographs.

The two men also discussed contemporary poetry. The monk was captivated by the spontaneous, stream-of-consciousness style of Beat poetry. He composed a long poem, an experiment he called an 'antipoem', in which he drew from all he knew of the spiritual as well as of the real world. *Cables to the Ace* appeared in the year of Merton's death in 1968, when on a rare trip to Asia he was electrocuted in a freak accident. Meatyard had known him for less than two years. Merton's passing was a blow, but the example of his eclectic tastes and diverse talents, the joy with which he played bongos and the solemnity with which he said mass, would help to sustain Meatyard in his last years. Merton wrote to Meatyard from Bangkok about his meeting in the Himalayas with the Dalai Lama. Even though this letter arrived after his death, it must have seemed to Meatyard that his friend had suddenly been swallowed up by the Asian continent. He had photographed Merton, whom his children referred to as 'Uncle Tom', on several outings to Gethsemani. Now, perhaps, the idea of systematically photographing his family and friends, thereby preserving his community and representing life in Lexington circa 1970, began to take shape in his mind. A prognosis from the doctor in 1970 that he was suffering from terminal cancer was, no doubt, a determining factor in the execution of the series he would title 'Lucybelle

Crater', published in 1974. Finished in 1971, the series consists of almost one hundred images of Madelyn Meatyard in an ugly, oversized, crone-like mask, photographed repetitively with immediate family, relatives, literary friends and their families. It has been suggested that the mysterious 'White Hat' series begun around 1968, for which Meatyard's wife Madelyn and daughter Melissa modelled, was the origin of this later, family-based collection. Both seem to owe something to the 1955 short story collection *A Good Man is Hard to Find* by the Georgian writer Flannery O'Connor. There, Lucynell Crater and her large, deaf-mute daughter, also called Lucynell Crater, are the main subjects of the comic tragedy 'The Life You Save May Be Your Own'. In typical O'Connor style, the picture of family life is unorthodox, the daughter a lonely, grotesque figure.

In deciding to portray his neighbourhood and friends, Meatyard was creating a portrait, albeit photographic, in the best American literary tradition. *Spoon River Anthology* (1915), composed by Edgar Lee Masters, was the earliest of these compilations of short, poetic portraits of small-town personalities. Meatyard probably consulted his 1963 edition of this American classic. Given his wide knowledge of American literature he was probably also aware of Sherwood Anderson's later *Winesburg, Ohio* (1919) and Thornton Wilder's 1938 play *Our Town*. His library was certainly filled with the writings of William Carlos Williams and his five-part poem *Paterson* (1958), a complex epic about place and autobiography. Meatyard's admiration for this work and his desire to translate it photographically, with Lexington standing for Paterson, has been noted.

Colleagues from the Lexington Camera Club, monks from Gethsemani, Merton's executor Tommy O'Flannagan and members of her family, and his office secretary each appear with Madelyn wearing a transparent mask that gives them the

haggard appearance of a man grown prematurely old. The cast includes writers Wendell Berry, Guy Davenport, Guy Mendes and Jonathan Williams, and photographers Van Deren Coke, Emmet Gowin, Robert May and Charles Traub, among others. It is a pantheon of sorts and might be compared to the historical custom of collecting images of the famous. At least from the time of Raphael's *The School of Athens* (c.1509–11), artists have pictured gatherings of celebrated artists and intellectuals, sometimes inserting themselves among them. The nineteenth-century French artist/photographer Nadar, for example, planned a series of large-scale lithographs combining his many caricatures of the Parisian cognoscenti in one long promenade. The Surrealist painter Max Ernst assembled his friends in the large group portrait *Au rendez-vous des amis* (1922), giving them mask-like faces and puppet-type gestures befitting their appreciation for the subconscious. Closer to Meatyard's time, photographer Robert Frank and painter Alfred Leslie made the film *Pull My Daisy* (1959) about their era, featuring their writer/artist/musician friends Allen Ginsberg, Peter Orlovsky, Gregory Corso, Larry Rivers and David Amram. Ginsberg would also be part of Andy Warhol's film pantheon *Screen Tests* (1964), a series of short film portraits recording the bohemian notables who frequented his Factory.

Meatyard's final series pays homage to his beloved family and talented friends, at the same time that it seems to caricature them. It was carried out with the same wit and cynicism that pervades his brief career. The mask allowed him to practise this style of fantastic irony. He discovered its importance through European Surrealist painting, the Noh drama of Zen culture, The Mask bar of Jack Kerouac's *Subterraneans* and the Halloween fun of his costumed children. His own best disguise was that of a Lexington businessman. He wore it until 1972 when he died too early, at the age of forty-six.

Untitled (Michael and Madelyn), Lexington cemetery, Kentucky, 1955. The birth of his son Michael in 1950 prompted Meatyard to take up photography. Four years later, he took his wife and son to the park-like cemetery laid out by master landscape architect Frederick Law Olmsted, Sr., and posed them before an Egyptian-revival mausoleum. Michael's sulky stance and garb recall the new Rebels – James Dean, Marlon Brando, Elvis Presley. The photographer's wife, in modish jeans and loafers, projects a Beat-style intensity. They could be the family of Dean Moriarty, or his creator Jack Kerouac, holed up in a temporary subterranean home. Or perhaps Michael is meant to be a modern-day angel protecting a sacred site.

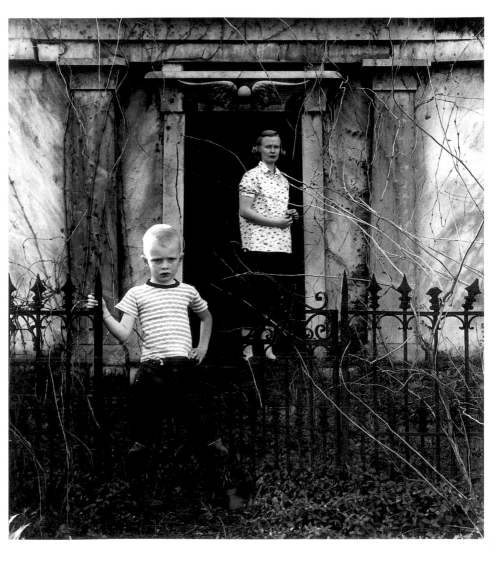

Untitled (Still life with doll parts, photographs and a dead mouse), c.1956–7.
Meatyard sometimes constructed and photographed free-standing assemblages. This composition, however, is a still life arranged on a flat surface. The influence of Dada artist Raoul Hausmann, of Joseph Cornell and of the Surrealist photographer Hans Bellmer can be found in Meatyard's eccentric collage. Both in order to shock, and probably as a comment on US race relations in the 1950s, he juxtaposes doll parts, a mirror-fragment that serves as a litter for a decaying mouse, and a battered wooden picture frame containing four portrait photographs of African-Americans. The egg-like doornob that rests in the crotch of the composite black-white doll may allude to the as-yet undelivered integration of the States.

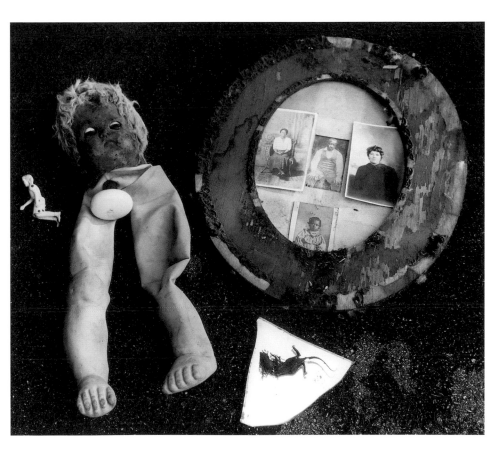

Untitled (Still life with Cranston Ritchie), c.1956–7. Cranston Ritchie (1923–61), a photographer colleague from the Lexington Camera Club, plays the dandy in this odd composition. One reading of the scene might be that this faceless gentleman has come to call on a man, suggested by the hat, necktie and braces on the right, and a woman, implied by the decorated handbag atop a lampshade in the gold-trimmed frame. Like most of Meatyard's characters, the 'couple' seems to occupy an empty, ruined space, but light from the window at the upper right, which echoes the shape of the empty frame, infuses the room with energy. The banal still life of the foreground seems to come alive for its mysterious visitor.

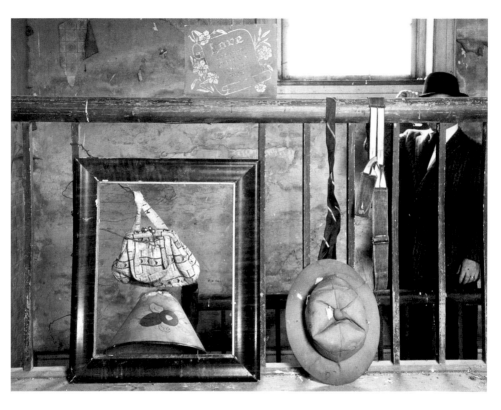

Portrait of My Mother-in-Law, c.1957–8. Ritchie's sensibilities seemed to be completely in tune with Meatyard's Surrealist tendencies and his enthusiasm for the work of the Belgian painter René Magritte. He allowed his friend to cast him in a role similar to that of Magritte's omnipresent, anonymous bowler-hatted man, posing with other attributes of the Surrealist's paintings, such as the three-legged chair and the empty boots. Meatyard includes on the mantelpiece a naïve painting of the Trojan Horse, suggesting perhaps that the battle of Troy and other trials of Odysseus could be compared to the difficulty of pleasing a mother-in-law.

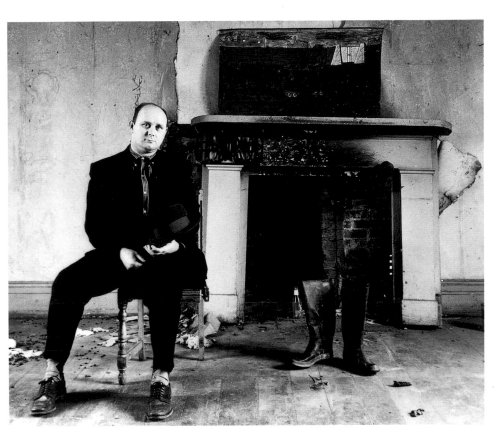

Untitled (Cranston Ritchie), c.1958–60. This picture was made after his friend's cancer had progressed to the point that he had lost most of his right arm. It owes something to the motifs of the disembodied hand and the monumental glove that appear in paintings such as *The Destiny of a Poet* (1914) and *The Song of Love* (1914) by the Italian Metaphysical painter Giorgio de Chirico. Meatyard presents Ritchie's disfigurement in combination with an artificial, feminine hand, in a way that heightens its grotesque surreality. Additionally, Ritchie's healthy left arm, enclosed in his dark jacket, seems to disappear into the darkness of the doorway, making it appear unattached, as it grasps the mannequin limb. This ominous union of male and female takes place over the deteriorating threshold of a derelict house.

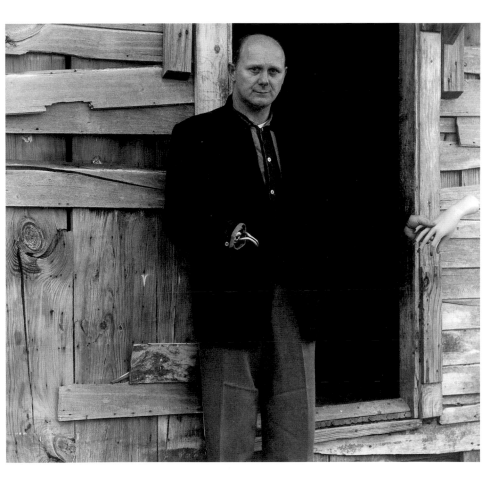

Untitled (Winter landscape), 1958–60. Landscape was a consistent element in Meatyard's vision, but it seldom appeared in a traditional style. At the end of the 1950s, he was attempting abstract camera-made images. He wanted to recreate the spontaneous, pure expression of Jackson Pollock's drip paintings, the improvisation of Dizzy Gillespie's jazz, and the concentrated simplicity of the Zen monk's haiku poetry. Meatyard was also interested in Eastern philosophy, encouraged by Minor White, and in finding the non-objective in the real world, as confirmed by Aaron Siskind's work. The elegant design of Harry Callahan's New Bauhaus images urged him to test the limits of the medium.

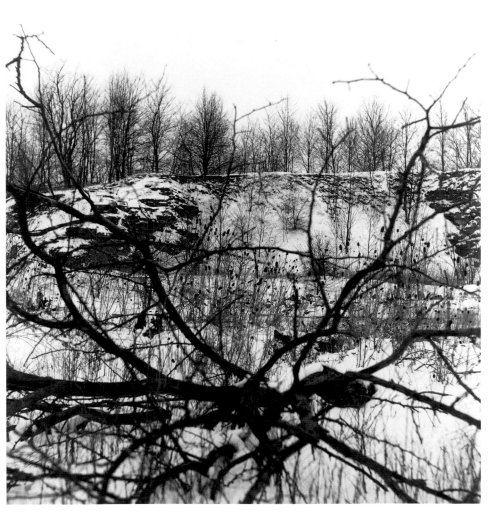

Untitled (Cranston Ritchie with mirror and dressmaker's mannequin), Lexington stockyards, Kentucky, c.1958–9. This image probably owes some of its inspiration to the abnormal characters in the stories of Flannery O'Connor's 1955 collection *A Good Man is Hard to Find*. But Meatyard was also looking at Giorgio de Chirico and the European Surrealists and here employs their penchant for the lifeless mannequin figure. A headless dressmaker's dummy is set up on a chair at a level suggesting a woman's height. Ritchie stands to 'her' left, his stiff pose and artificial limb making him seem her unnatural match. One reading of the fanciful coupling might be the marriage of an injured Civil War veteran and an African-American woman. The marriage theme suggests another, more remote model: that of Jan van Eyck's fifteenth-century masterpiece, *Giovanni Arnolfini and His Wife* (1434).

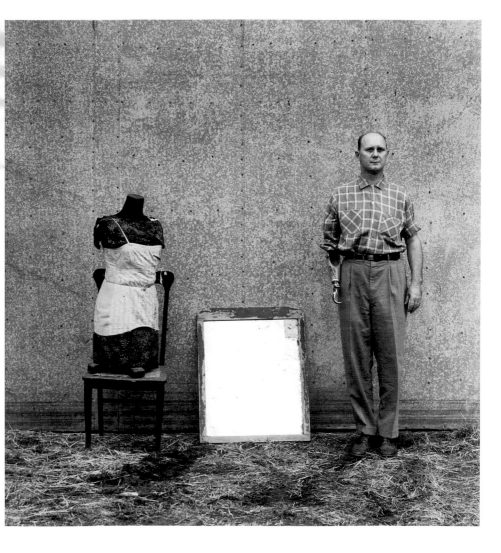

Untitled (Christopher, twice), 1959. It is difficult to know at what point Meatyard became aware of the painter René Magritte, one of whose best-known compositions is *The Menaced Assassin* (1926) — a silent drama featuring the heads of three men observing a murder scene. Meatyard appears to have borrowed the idea of identical heads peering over a barrier and framed in a landscape. Here he uses his second son Christopher in a double exposure to accomplish what Magritte did with paint. Christopher is pictured both with eyes closed and open, suggesting night and day, but the duplication of his innocent face and the near symmetry of the image creates an otherworldly sci-fi aura, recalling the arrival of the bewitched blonde children in the 1960 film *Village of the Damned*.

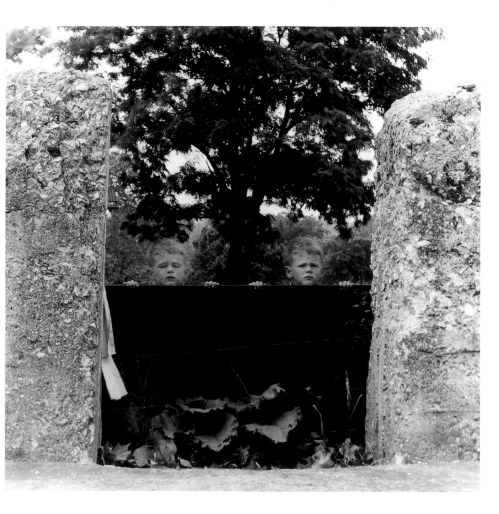

Untitled (Still life with dolls under glass), 1959. In the course of assembling ordinary items in odd ways so that he might transform them through photography, Meatyard decided to put dolls behind glass and under water. He could then see how the camera would record the special surface and magnifying qualities of both. The resulting distortion is just enough to make the small pigtailed-doll in the centre seem to be rocking in a life-like fashion and the large upside-down doll's head descending at the left look like a monstrous intruder. A misshapen hand reaches up from the depths towards the oblivious girl-doll.

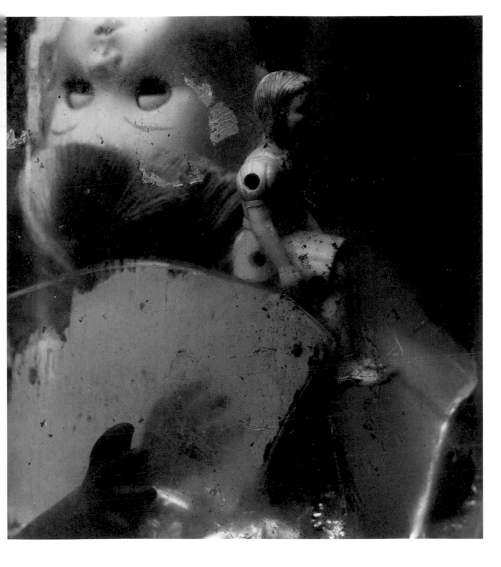

Untitled (Michael and Christopher), 1959. In the 1950s few photographers, particularly men, chose their models from their own families. Meatyard, however, found inspiration in his three offspring. This was perhaps due to his interest in Ben Shahn's postwar paintings of Italian children playing among the ruins of war; the dolls, puppets and children in Rainer Maria Rilke's poetry; and the dwarves, elves and hobbits of J.R.R. Tolkien's epic fantasies. But he did not emphasize their innocence. Instead, he cultivated their uninhibited nature, unpredictable gestures and natural acting abilities. The weathered rural architecture provides the kind of abstract elements – the horizontal slats of wood against the strong verticals of the barn-like structure – that Meatyard preferred as context for his figures.

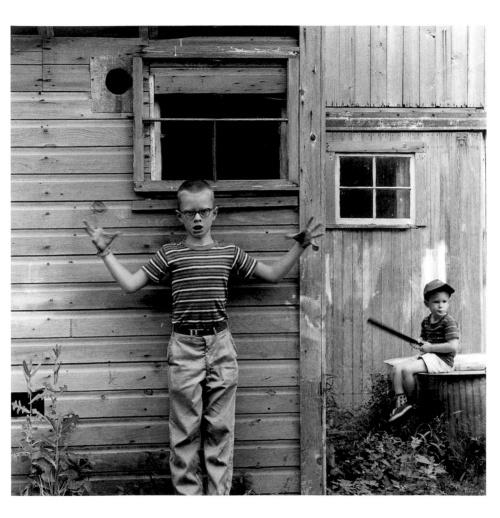

Untitled (Landscape with barbed wire fences and telephone poles), 1959. This prairie landscape appears common at first, but on closer viewing proves far from normal. It was probably made during a trip that took Meatyard north all the way to Wisconsin. The different elements of the composition are strategically sited so that the lines of fence, telephone poles and road appear to overlap and intertwine in the shallow space of the photograph – an illusion enhanced by the early morning fog that conceals the distant horizon. Adding playful lines and shapes to this interwoven landscape, which seems to be all foreground, is an inexplicable wire sculpture hanging on the fence.

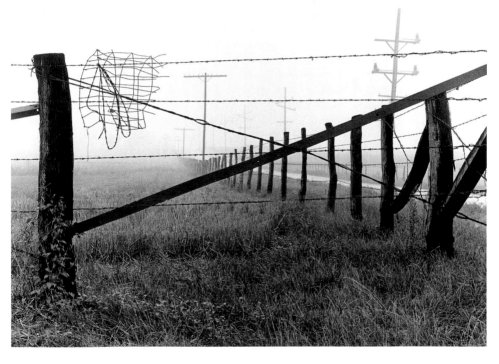

Christopher and the Rebuilding of America, 1959. This photograph is found in the portrait section of the Time-Life publication *Photographing Children* (1971) and is described as a 'direct view'. It is anything but. The 'Rebuilding' of the title may refer either to the continuing reconstruction of the post-Civil War South or to the current turmoil of integration in that region. The expensive Arcadian wallpaper of this decrepit mansion no doubt signifies the aristocratic, ruined Confederacy. The damaged doll perhaps symbolizes the previous tenants who were forced to rejoin the Union (or, in this case, to form a union with the boy, who stands in for the North). The boy possibly also signifies America's youth or, given Meatyard's cynicism, its ignorance.

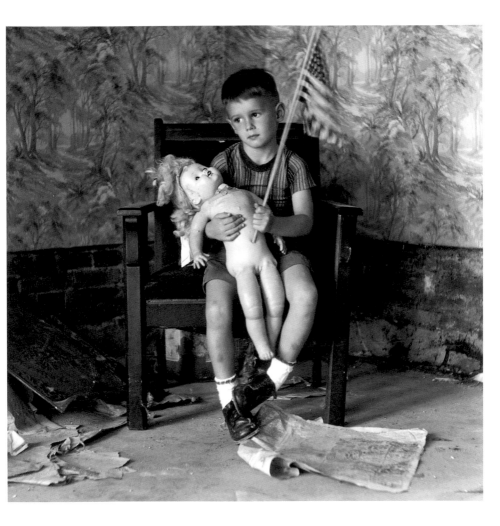

Romant #45, Kentucky, 1959. Meatyard used the ornamental elements of a mausoleum to create a gallery for his theatrical props. The composition has a backstage feel: the dolls and masks look like performers waiting for their next cue. Christopher can be seen as a tiny stagehand supporting even tinier, fairy-like actors. The setting is northeastern Kentucky, but the aged stone pillars, wild undergrowth, ghoulish masks and decapitated dolls lend it the air of a (slightly unorthodox) classical tragedy, or, as the title — an archaic form of 'romance' — might suggest, a fantasy staged somewhere in the Mediterranean.

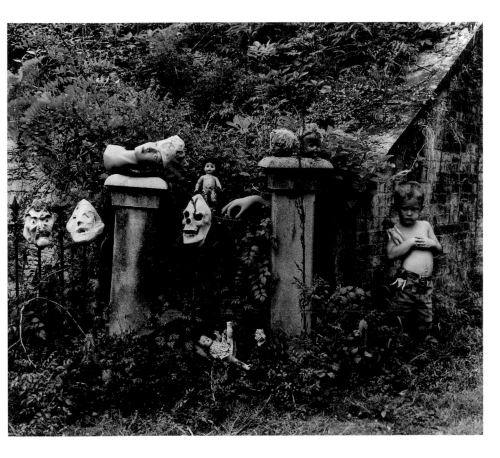

Untitled (Christopher with doll and American flag), 1959. The boy seems to be cowering, expecting punishment for something he knows he should not have done. This may involve mistreatment of the doll, or the implication may be that he is suffering from abuse himself. The setting is adult, masculine, slovenly, and the association of crouching boy with undressed doll, the small, cheap flag covering her crotch, creates an erotically charged but puzzling aura. The photographer's ironic humour can never be discounted. Other images in this series include one that situates Christopher with his doll and flag in the midst of a vast expanse of rubble, another in which he stands with the flag in front of a decaying plaster wall, and a composition with him holding the flag in front of his face, in yet another nod to Magritte.

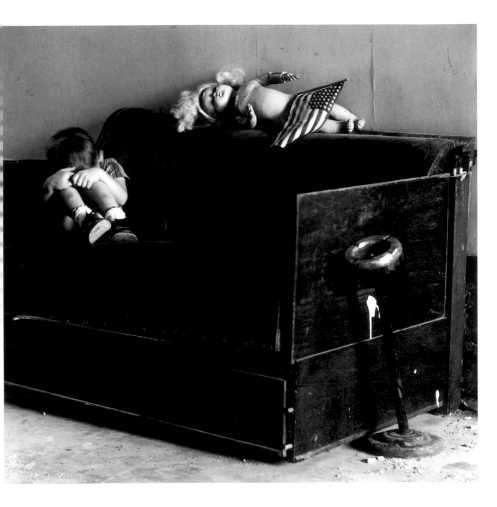

Untitled (Cranston Ritchie in a landscape with abandoned building), c.1959–60.
Meatyard's alliance with Ritchie was personal as well as artistic. It was based on a common sense of humour and appreciation of the bizarre. In a typically desolate site, Ritchie poses like an Ingres odalisque or Manet's *Olympia* (1863). Unlike Manet's immodest figure, however, the fully-dressed Ritchie does not need to cover his genitals with his right hand; however, his mechanical arm does seem to point to them. Ingres and Manet are not the only progenitors of this deviant composition. Meatyard may again be looking at the paintings of Magritte, such as *Elementary Cosmogony* (1949). He may also be imitating, in an original way, Ben Shahn's painting *Carnival* (1946), in which the reclining figure of a sleeping man fills the foreground.

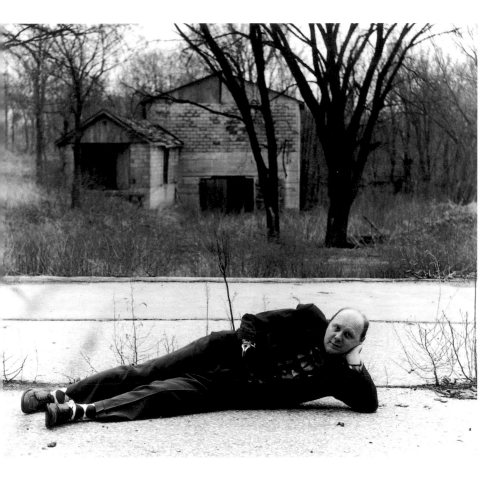

Untitled (Christopher with tree stump and hubcab), c.1959. This shiny hubcap is something Meatyard would typically save from the rubbish for use as a prop. His creative method also involved experimenting with exposures that captured the movements of his subject and of the camera itself. Props, action and camera work resulted in pictures that seem to contain more fiction than fact. Here we see a child playing with an object that at first looks like an enormous, glowing mushroom. Given that the image was taken at the height of the Cold War, it may well be that Meatyard intended to reference the fear and fascination of the bomb. Flying saucers and the space race also come to mind. NASA had just been set up, and the first seven American astronauts chosen, while Russia had already launched Sputnik II (1957).

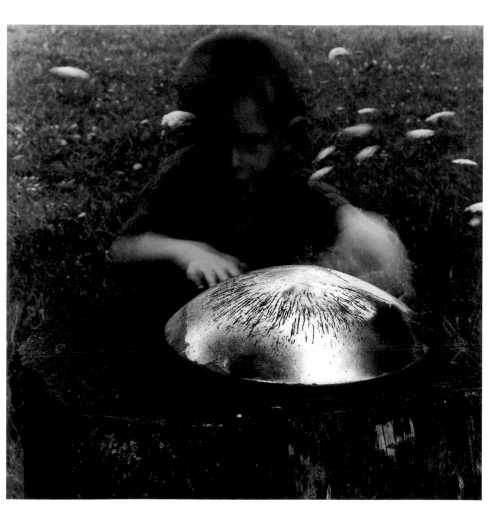

Untitled (Two dolls, one headless), c.1959. Discarded dolls of all types and in all conditions were an essential part of Meatyard's repertoire. He used them in still-life compositions, in tableaux that featured his own children and as creatures conjuring their own fantastic space. This simple but unusually graphic image implies an uncomfortable integration of the black and white races. Meatyard's sensitivity to current events, popular culture and the world of art suggests that he may well have created in sympathy with the handful of other artists attempting to tackle the subject of racism, such as John Cassavetes, whose first film, *Shadows* (1959), focused on a black-white romance, and Jack Kerouac, whose novel *The Subterraneans* (1958) chronicled a troubled affair between the white narrator and a woman of Negro-Cherokee descent.

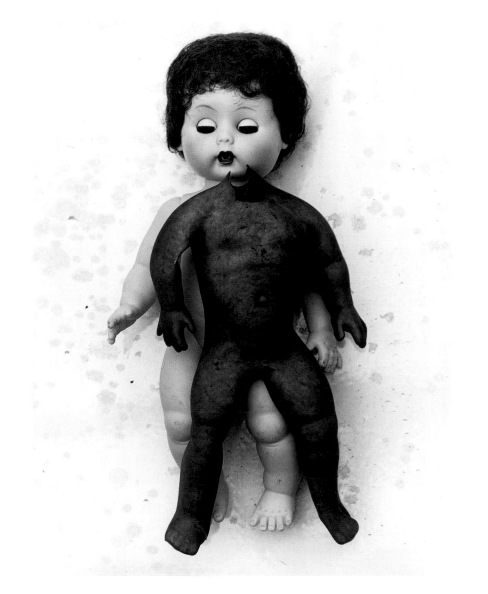

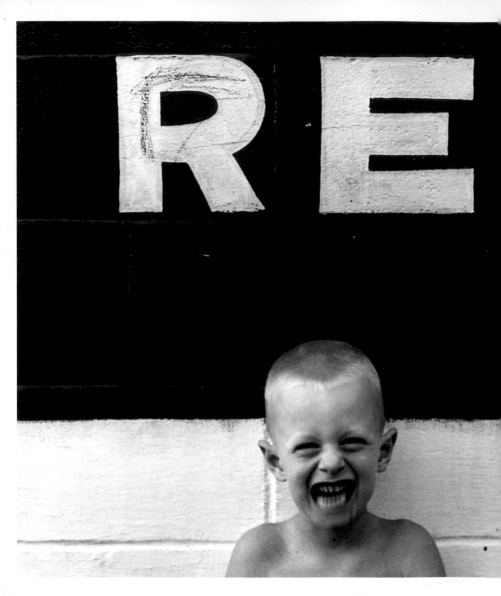

(previous page) Untitled (Michael with 'RED' sign), 1960. In this simple but loaded image, the young boy's uninhibited grin becomes almost a grimace, exaggerated by the photographer's long exposure. This grotesque hilarity, in combination with the word 'RED', could be read as a reflection of the irrational Cold War witch hunts for Communist Party members carried out by Senator Joseph McCarthy. It could also be a playful comment on the use of the word 'red' in a black-and-white photograph. Though it has monumental graphic power at this size, it still has no hue. Not only that, but this 'loud' colour has no sound, just as the snickering boy is reduced to silence. These references to silence and language, which would continue to influence Meatyard's creations, trigger comparisons with Zen Buddhism, conceptual art, John Cage and Jasper Johns.

Untitled (Extended family portrait with Christopher, Madelyn holding Melissa, Ruth Meatyard [the photographer's mother], great uncle Gaddis and Michael), 1960. The photographer's family — his three children and his wife Madelyn — are shown here with his mother and his great uncle on his mother's side. They are posed, each isolated from the next, in the yard of what is probably an abandoned farmhouse. Meatyard has succeeded in making a strange portrait of his average, middle-class family, which implies alienation, indifference and rural poverty. These four generations of Americans seem to have taken their places on a stage, about to enact a family drama — perhaps not one as cynically absurd as Edward Albee's contemporaneous *The American Dream* (1959–60), but one filled with the loneliness of the independent Northerner and the melancholy of the isolated Southerner.

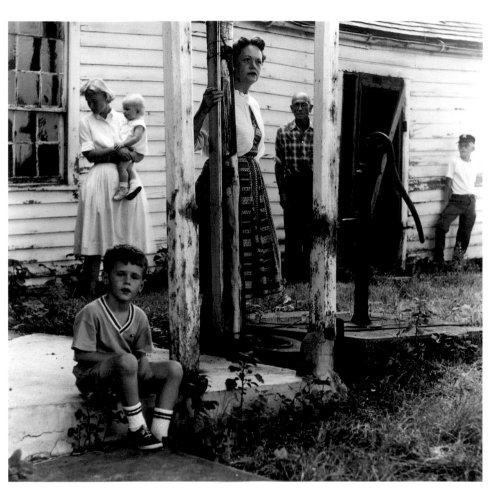

Untitled (Michael and Christopher with American flag), 1960. It seems likely that the location in which the two Meatyard boys are shown is the deserted interior of the Lexington, Illinois house that their father selected for the 'family portrait' on page 53. A fourth of July holiday provided the photographer with a reason to compose around the American flag, although this was a recurring motif in his work. The flag has memorial connotations, but its reference to nationalism calls up not only the Revolutionary War, but also American involvement in the World Wars and the Korean War. The pensive mood of these boys (future soldiers?) in conjunction with this powerful, graphic symbol perpetuates the ambiguous Americanism of Meatyard's family portrait and provokes comparison with the lonely figures in vacant rooms painted by the twentieth-century American realist Andrew Wyeth.

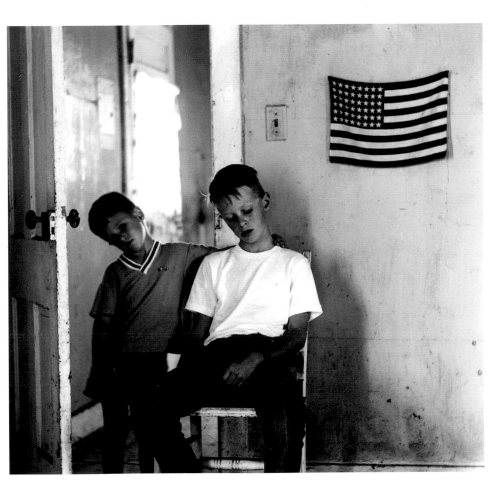

Untitled (Flag – derelict interior with Christopher), 1960. The Pop Art movement was underway and Meatyard was in sync with its iconography as well as its controversial techniques. His mischievous rendering of the flag from the found strata of household plaster and planks is in tune with the painted flags of Jasper Johns, and with those of Claes Oldenburg made in scrap wood and cardboard that same year, as well as with the assemblage techniques of mixed-media artist Robert Rauschenberg.

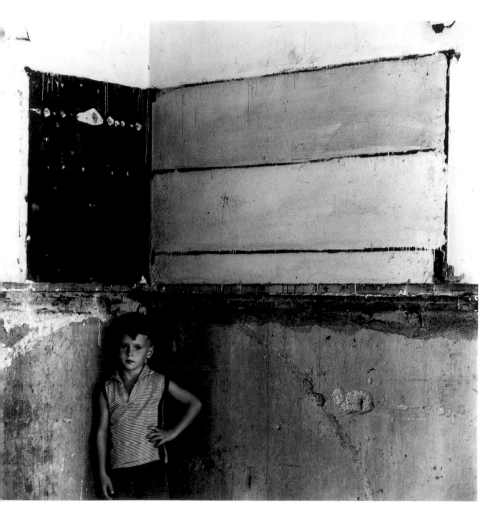

Prescience #135, 1960. The porches of a battered mansion, possibly at Redhouse, Kentucky, in Madison County, form the backdrop for this tableau of Christopher and Michael. The boys' forlorn expressions amplify the atmosphere of loss and longing already implied by the deserted Civil War-era architecture. It is impossible to know whether the title refers to the older child prefiguring the future of the younger, the political foresight that should have prevented the carnage of the War Between the States, or the fact that the photographer simply liked the sound of this word 'prescience', just as he chose to go to Redhouse because the name was so evocative.

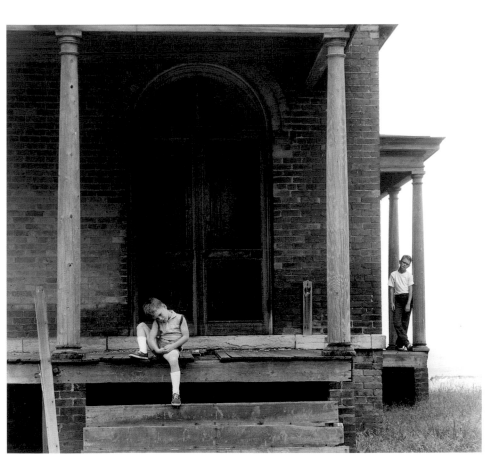

Untitled (Michael and Christopher outside brick building), 1960. This composition is constructed in a shallow space, again using the deteriorating nineteenth-century house as a locale that combines a historical aura with strong geometric elements. Against a backdrop of brickwork, Meatyard's children perform. Michael is transformed into an angelic form in white tunic, captured, with a long exposure, descending to earth (or ascending into an arched opening?). The action of this central figure seems incongruous in the stillness of the scene. Its movement enhances the hush of the dark window and the mute, empty chair on the left, as well as the stillness of Christopher, who stands on the right. Always intrigued by the mysteries of 'authored' vision as opposed to straightforward 'seeing', Meatyard reveals motion that could not otherwise be perceived.

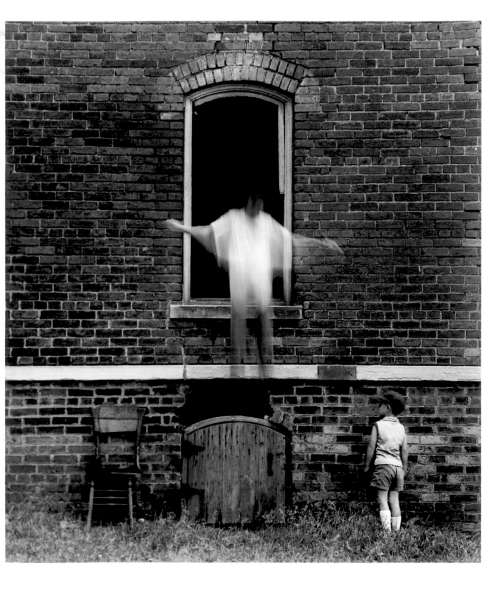

Untitled (Portrait of Christopher and Michael in the doorway), c.1960. Meatyard's children were not the model suburban types of the new TV family sitcoms. The imaginary world they created with their father was sometimes forbidding, sometimes capricious, consistently true to the intense duality of childhood expression. From picture to picture they might be compared to the equivocal characters of early 1960s films, such as the aristocratic Miles and Flora, who subtly drive their governess to distraction in *The Innocents* (an adaptation of Henry James' *Turn of the Screw*), or Jack, Ralph and Piggy, orphaned by nuclear holocaust, whose behaviour reflects the beastly side of youth in *Lord of the Flies*.

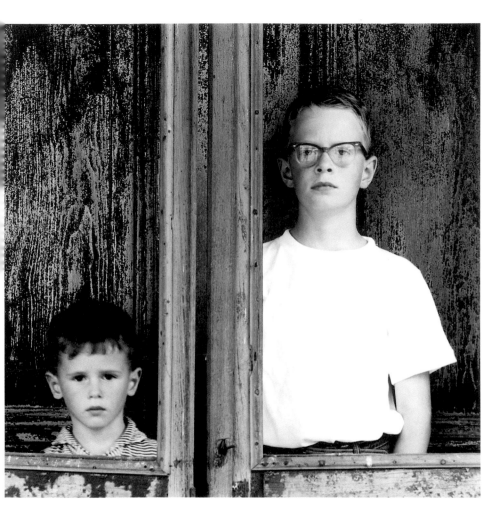

Untitled (Michael in front of deteriorating wall), 1960. Edgar Allan Poe's prose and poetry was included in Meatyard's extensive library; his influence is seen in the photographer's abandoned mansions, deep shadows and winged imagery. Birds — owls, crows and doves — were also part of Magritte's *oeuvre*. The ruined houses that Meatyard haunted supplied him with ample suggestions of the grotesque. Here, his camera has recorded Michael seemingly without arms, yet ready for flight with the wing-like forms provided by the peeling paint above. The round black hole yawning between them is another pictorial element repeatedly borrowed from Magritte. Probably originally housing a stovepipe, it becomes a threatening motif, poised to swallow the boy as he takes flight.

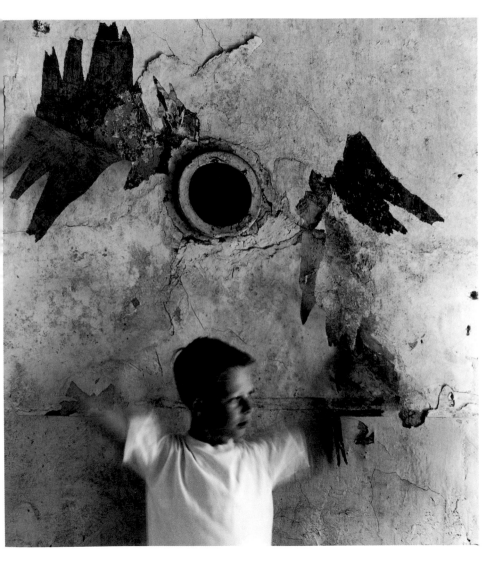

Life of Aspersorium, 1960. The photographer's sons pose opposite each other in silent, waiting mode, as if expecting a ritual to begin. Crumpled fabric on the floor between them adds an abnormal, perhaps supernatural, element. Have the two youths witnessed some secret ceremony? The 'Aspersorium' of Meatyard's title must be considered. The dictionary definition of this medieval term is a container for holy water to be used in performing rites. Does the shiny globe of the chandelier possess the qualities of this sacred vessel, or does the title imply that Aspersorium was a creature who has just vanished before the eyes of these stunned children?

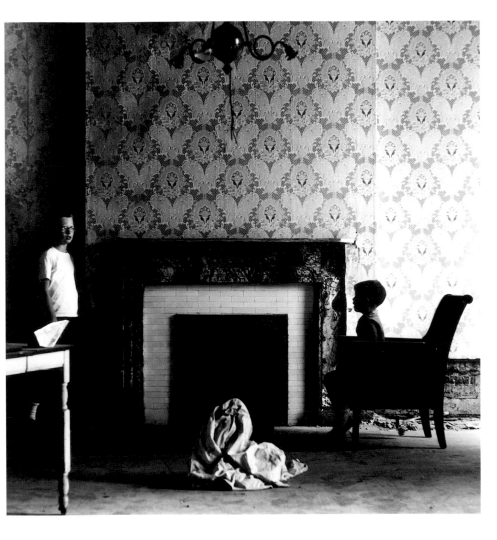

Untitled (Still life with doll, framed photograph and broom), 1961. This is another composition relevant to the theme of rebuilding race relations in America. The Civil Rights Movement would explode in 1962 with riots incited by the forced integration of the University of Mississippi. Freedom Riders were travelling on buses throughout the southern states, protesting, with non-violent action, about racial segregation. In reaction, the John Birch Society came to life in 1958 to ensure that prejudice prevailed. Meatyard's reading included Gunnar Myrdal's 1944 volume on the gross inequalities of American life, *An American Dilemma: The Negro Problem and Modern Democracy*, as well as the more recent *Black Like Me* (1961) by John Griffin and *Preface to a Twenty Volume Suicide Note* (1961) by black poet Amiri Baraka (LeRoi Jones).

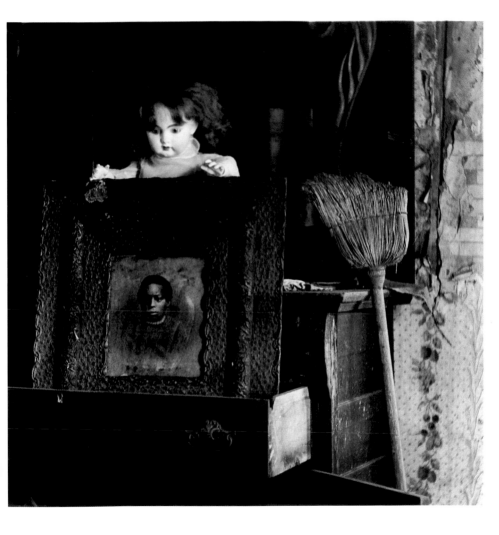

Romance (N.) from Ambrose Bierce #3, 1962. Meatyard took his definition of romance from *The Devil's Dictionary* (1911), compiled by American writer Ambrose Bierce from the satirical pieces he published weekly in the late nineteenth century. The American grotesque of Bierce's tall tales is here combined with Meatyard's Surrealist inclinations and the European, particularly French, interest in primitive masks, perhaps with the intention of creating a parody on high art. Rather than sports fans, the stadium benches are occupied by indifferent gnome-like creatures wearing macabre, oversized, dime-store masks. A blending of cultures, real and imagined, confounds the viewer, as it does in Picasso's landmark painting of 1907, *Les Demoiselles d'Avignon*. While quoting Picasso, Meatyard also references current Pop art (with the numbered benches) and comments on their contradictions.

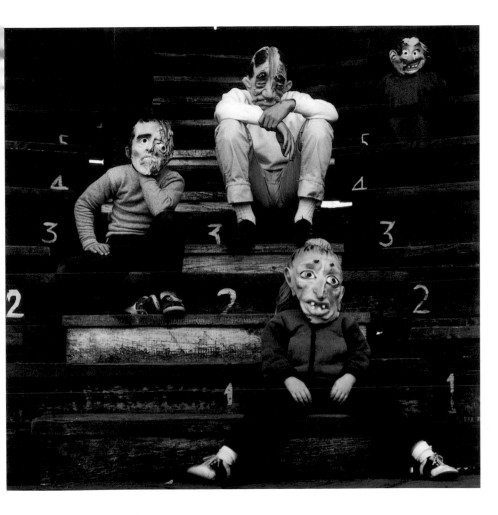

Chapter Pain #3, 1962. The pain referred to in the title may refer to that of Christ. The photographer's older son is seen in a contorted pose that seems to imitate that of a crucifixion. However, the boy's backward glance may indicate the pain of trying to retrieve the past. Another possibility, given Meatyard's appetite for art-historical references, is that the outline left by the form of a previous window is to be read as the weighty frame of a tableau vivant whose subject is Picasso's minotaur. The ancient monster, made more abstract, is now a long-horned bull-boy whose potential aggression is suggested by the blurred figure below him.

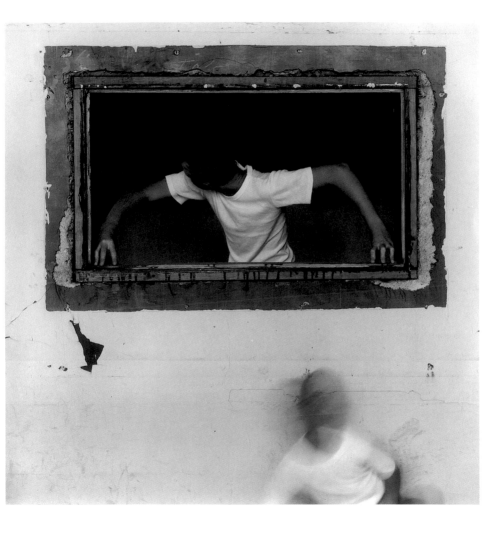

Untitled (Michael with discarded windows), 1963. The frame was a recurring motif that Meatyard seemed to find endlessly fascinating. Here, his son Michael squats frog-like behind one of two narrow, white-framed window panes. The verticality of the frame causes the boy's limbs to be truncated. His arms and mittened hands, left outside the frame, look like the wings of a feeble young bird. The confinement of the frame also has the effect of reducing the boy to a dwarf's proportions. Additionally, his hooded jacket suggests the garb of an elf or hobbit-type being, while his glasses evoke a strange, spectacled sorcerer. The cracking walls and exposed bricks, combined with Michael's low pose under glass, all contribute to the sense of a subterranean, almost sepulchral, setting. The repetition of nearly identical frames emphasizes the transformative power of this simple device, whether filled with a face or holding only reflective glass.

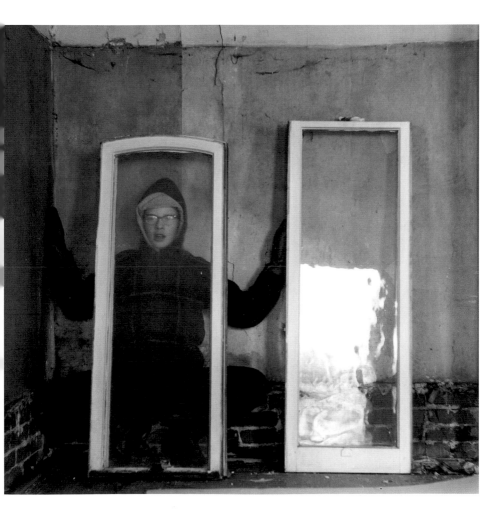

Untitled (Light on water), 1963. In the late 1950s, influenced by Minor White and his philosophy of applying Zen principles to camera work, Meatyard began an extensive series to which he gave the general heading 'Light on Water'. He would continue experimenting with these light drawings, which he approached as a kind of meditative exercise, until his death. In exposing his film to the unpredictable movement of light on water, he gave himself over to the improvisation of natural forces. The random calligraphy recorded in this composition is reminiscent of both the haiku of Zen poets and the contemporary canvases of the expatriate American painter Cy Twombly, who converted the profound gestures of Abstract Expressionism into rough, semi-literate lines of graffiti.

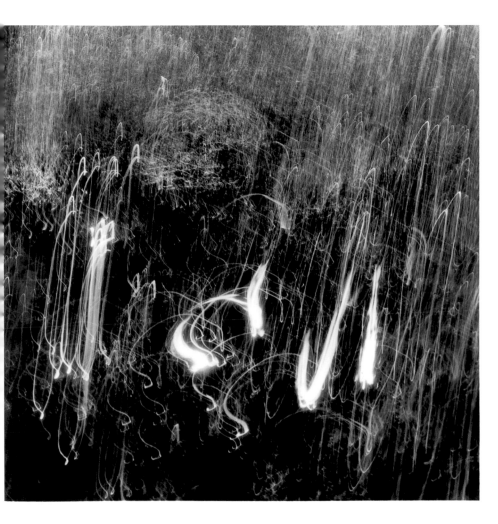

Untitled (Michael behind the leaves), 1963. Michael Meatyard (1950–2000) was his father's inspiration for buying a camera. His adult life was cursed with serious health problems, just as his father's had been, and he died at the age of only forty-nine. In retrospect, this image of Michael behind tree branches has an elegaic tone. At the time, however, the confusion of sunlight and leaves that replaces Michael's face may have been Meatyard's attempt at portraying his son's bewildering adolescence. On the other hand, he was constantly playing with the possibilities of more or less focus to give his pictures the balance of abstract and figurative elements he sought. This effort led him to make a series of images he called 'No-focus', which, without the defining lens, recorded the objective world as non-objective.

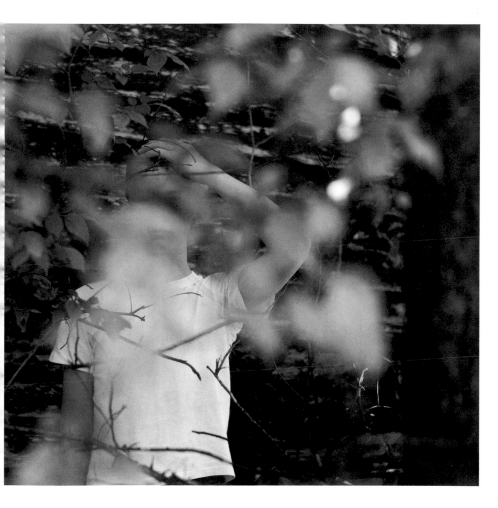

Untitled (Madelyn, Michael, Christopher and Melissa at the entrance to an abandoned house), 1963. An odd family portrait, this composition is more a picture of place than a record of the photographer's shivering wife and children. Like his contemporaries, Edward Hopper and Andrew Wyeth, Meatyard worked with the people and neighbourhoods he knew and whose history he appreciated. Each of these artists seemed anxious to recover a part of the past. Meatyard's locale was rural Kentucky. The area's abandoned eighteenth- and nineteenth-century structures provided authentic settings for scenes such as this, which emanates the isolation of Hopper, the melancholy of Wyeth and the fantastic irony of Meatyard. Christopher stands in a window that also resembles a guillotine; Michael helps a doll through an opening in an old door; Melissa rushes to her mother. All wear hooded sweatshirts like modern hobbits.

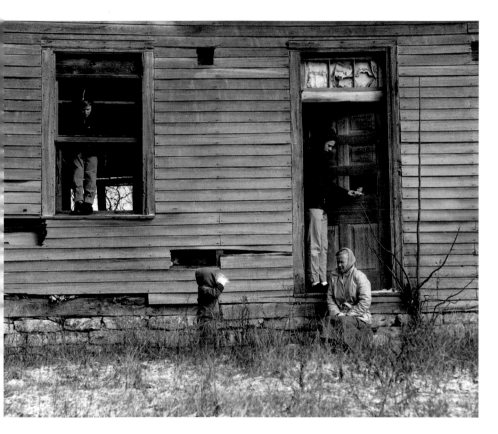

Untitled (Melissa on the couch), 1964. The nude was not part of Meatyard's repertoire. The only others he is known to have made are a couple of 1960s images of his friend, the poet and publisher Jonathan Greene. Melissa may have just come from a bath. She was four or five years old and already used to posing for her father. Her reaction to this moment before the camera, however, seems to be more hesitant. She appears somewhat reluctant, if not confrontational. The photographer neither exploits nor idealizes his daughter. His picture of childhood acknowledges both its innocence and its awareness.

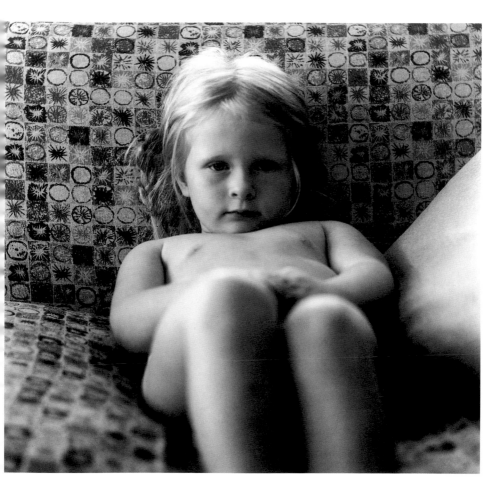

Untitled (Three silhouettes), c.1964. Posing his figures against strong back-lighting, Meatyard allows his camera to draw only the outlines of his subjects. The delineation of the windows and walls situates the figures in a tight framework, which creates a bold division of the composition enabling two scenes to be observed at once. The deep shadows are reminiscent of Hollywood melodrama. The atmosphere is tense, though ambivalent — an anxiety appropriate for the moment between the assasination of President John F. Kennedy and the dawn of the Vietnam era.

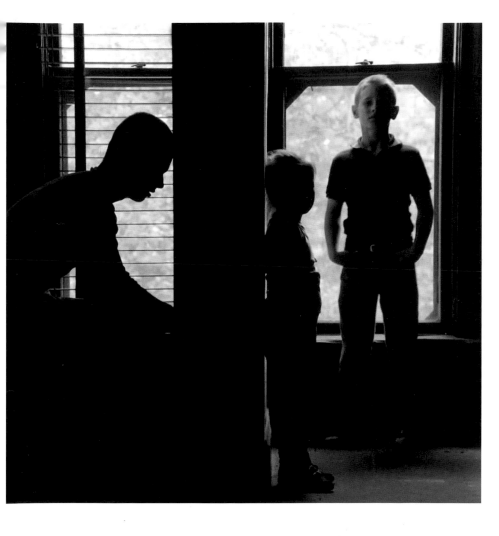

Madonna, 1964. Madelyn Meatyard was an indulgent model. The role her husband usually chose for her was that of mother, posing with one or more of her three children. Here, he stations her before an arched window. The pious atmosphere created by this framing is contradicted by Madelyn's everyday dress and by the dilapidated Venetian blinds behind her. Unlike a traditional religious icon, this Madonna gazes sternly into space, while her small child stands facing the maternal loins from which she sprang. Many photographers prior to Meatyard – such as Alfred Stieglitz, Edward Weston and Harry Callahan – had produced series based on their beguiling wives.

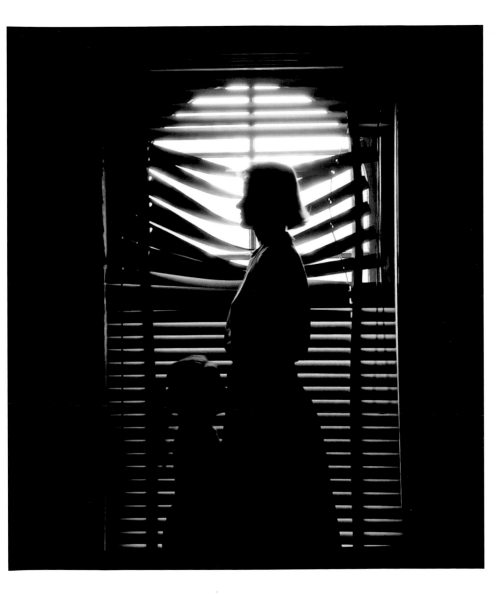

Untitled (Interior with man looking at empty niche), 1964. This unidentified, bespectacled man gazes at a gritty niche probably left by an old medicine cabinet with mirror attached. The ruined light fixtures to either side no longer hold bulbs. Meatyard's vocation always involved vision. He read publications on eye diseases and the techniques of eye dissection. He dealt with lenses and the problems of sight every day at his shop. It is not surprising, then, that he poses puzzles of this sort: since there is no mirror and no light to illuminate it, is this isolated man without an image of himself? Or, does he see his reflection in an imaginary mirror?

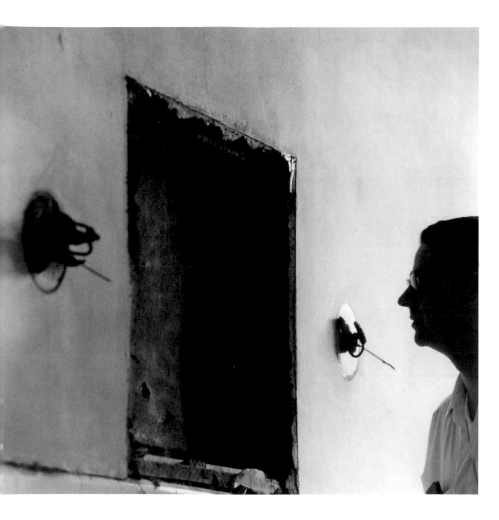

Untitled (Interior with man turning his head), 1964. Resembling a tightly focused haiku, this image was composed swiftly. Its subject is something of a riddle. It seems to relate to the creative action of decay (represented by the peeling paint) and the transformative power of human movement seen in slowed time. The broad stain of paint on unprimed canvas was a technique popular with contemporary American 'color field' painters, such as Morris Louis and Helen Frankenthaler. Meatyard's is a found brushstroke, and, in conjunction with the human, though abstracted, element, it recalls the ingenious assemblages of paint, found objects and photographic materials created by Pop artist Robert Rauschenberg.

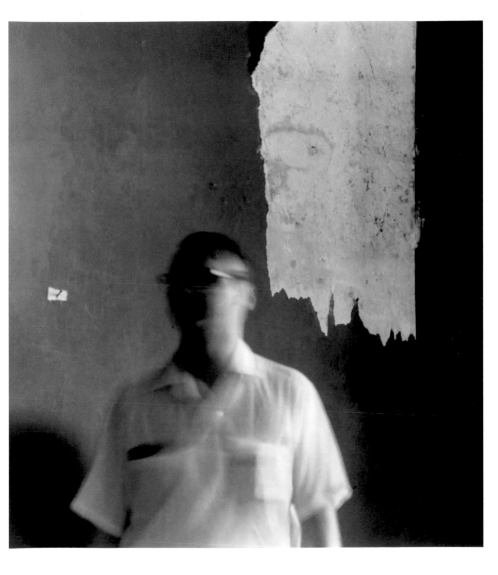

Untitled (Christopher with glass fragment covering his face), 1966. Christopher Meatyard remembers his father arranging him beneath the graffiti-covered plaster arch with a shard of glass carefully positioned in front of his face. Light nearly destroys the transparency of the glass, replacing the boy's face with its own reflection. In this setting, Christopher's hooded sweatshirt gives him a cloistered or mystical character. The sharp blade of glass points upwards to old scratched inscriptions implying that they contain ancient wisdom or chants to be uttered by this avatar of the occult.

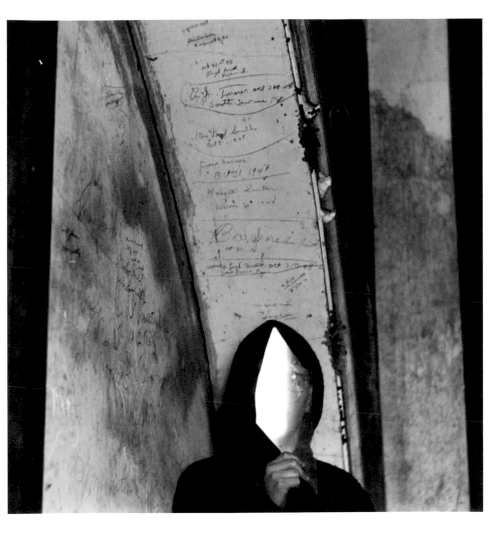

I Have Refused to Accept – #1, 1966. Meatyard's expanse of flowers gives the eye no place to rest. Frederick Sommer's earlier desert landscapes and Harry Callahan's mid-western fields share the flat, overall design of Meatyard's composition. Those tilted vistas would have been known to him primarily through photographic journals, such as *Aperture*. And the idea that the photographer should seek to destroy (or refuse to accept) the depth fundamental to normal vision obviously appealed to him. His approach was similar to that of the new Op artists, such as Larry Poons, who constructed a system of coloured shapes on his canvases, and Victor Vasarely, whose methodical geometric forms painted in black and white played tricks on the eyes.

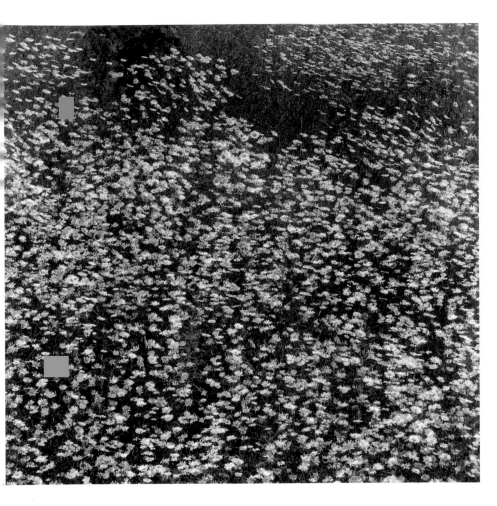

Untitled (Three children silhouetted against a window), 1967. On a visit to his home town, Bloomington, Illinois, Meatyard made this image employing his nieces. The girls' pretty profiles and happy rapport combined with the silhouetted style is reminiscent of children's book illustrations. It implies a fairy-tale-like narrative, probably with a happy ending. But the children's faces cannot actually be seen and the action is silent. A conspiracy may be afoot. Their plotting seems to be taking place in a tower or an attic room. Are they planning mischief to confuse their unimaginative elders?

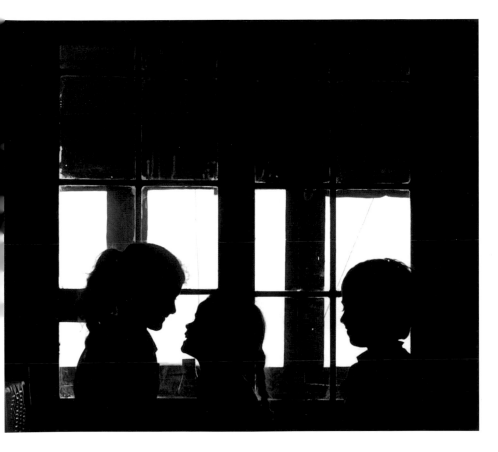

Untitled (Melissa behind the glass), 1967. Made on the same visit as *Untitled (Three children silhouetted against a window)* on page 97, this picture presents the opposite point of view. Far from the anonymity and abstraction of that silhouetted portrait, Melissa's visage confronts the viewer close-up, her forehead meeting the picture plane. Although fully exposed, her appearance is disfigured by the glass. Transparency is no guarantee of clarity, the photographer seems to be saying. The girl's furtive expression also suggests an absurd game of hide-and-seek with her cousins. She has 'covered' herself with a curtain of glass, hoping to fool her assailants.

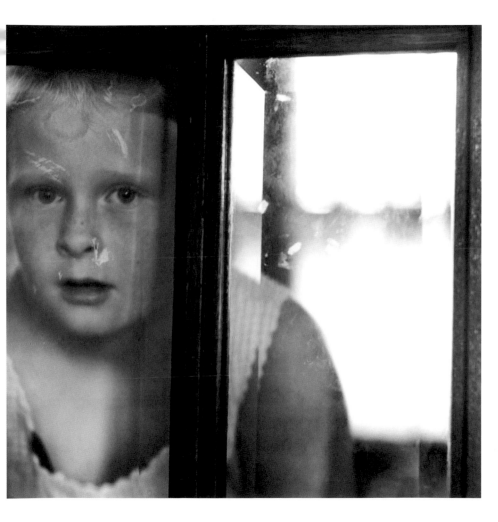

Untitled (Melissa and her cousin on a porch swing), 1967. This light-hearted view of youth is unusual for Meatyard. Photographing his daughter in the place where he grew up, he lets the buoyant joy of childhood come through in her laughter. He understood the pleasure children find in playing outdoors with friends, just as he appreciated their unsuppressed creativity. Melissa's cheerful nature seems to have inspired these more frivolous but carefully composed photographs, which reference his mid-1950s images of boys romping on the sidewalks of Lexington's Georgetown Street neighbourhood.

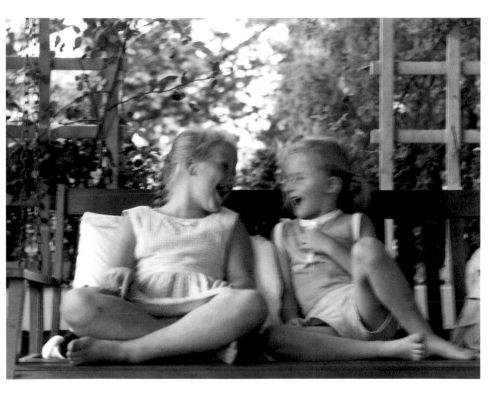

Untitled (Melissa and Christopher on the porch of a vacant house), 1967. Meatyard captured the wise as well as the ignorant side of immaturity; here Christopher looks amazed while his sister remains calm, possibly because she is the cause of the disturbance. The littered porch and broken chair suggest poor, negligent parents or even that the children are the only inhabitants of the derelict house. Joyce Carol Oates' stories of the abused or ignored come to mind. Like Meatyard, she finds the abnormal in the normal; her children come from the centre as well as the fringe. Returning to photography, one finds manifestations of Meatyard's cunning children in the young subjects of Emmet Gowin, Danny Lyon, Sally Mann and Nan Goldin.

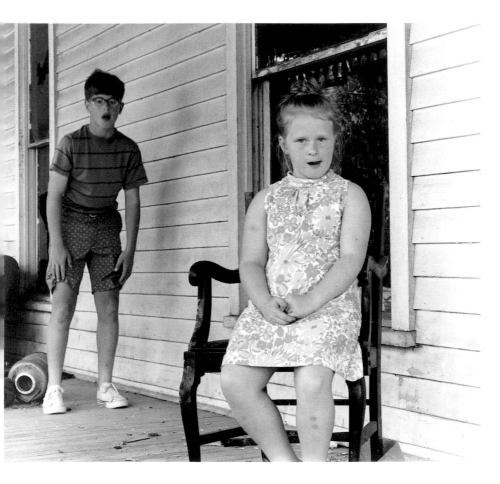

Untitled (Christopher with clothesline and rubber chicken), 1967. Far from being an adolescent joke, the rubber chicken was probably the father's idea and the boy may not have known why he was holding it. He eats an apple, seemingly oblivious to the bizarre appearance or possible symbolism of this very dead-looking creature, which in black and white almost passes for real. One almost expects that, after finishing his apple, the boy will string the bird up on the clothes line and go off to find more.

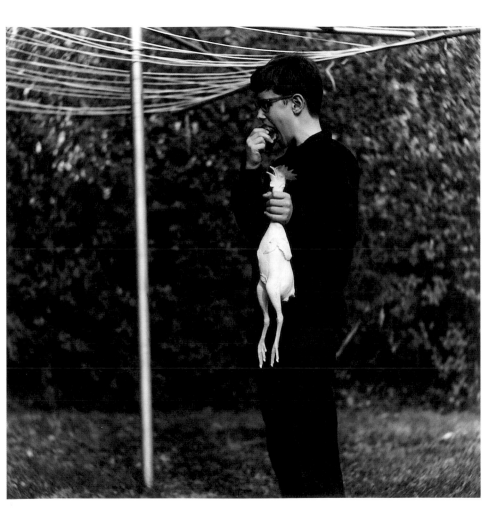

Untitled (Three sisters), 1967. A summer visit to Antioch, Illinois, produced this formal, static portrait of girls wearing hot-weather haircuts and sleeveless, flowered outfits. The figures have been identified as sisters. The youngest is presented as a ghostlike face in the foreground. Her oldest sister, in the middle ground, stands behind a piano that truncates her body, allowing only a bust-length portrait. She seems to emerge out of the top of the piano; her left arm hugging its side. The middle sister, more complete and in focus, is shown in the background. A mirror with knick-knack shelves, which might be the elaborate headdress of a middle-western tribe, frames her head.

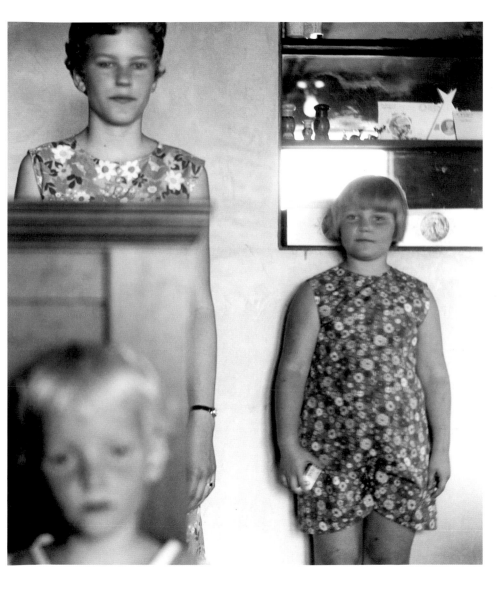

Untitled (Three dancing girls), 1967. In an image probably made seconds after the one on page 107, the oldest girl is seen dancing with other girls in the living room while her parents try to rest and read *The Saturday Evening Post*. This may also be part of the tribe's Sunday afternoon ritual. Capturing the figures against intense sunlight, Meatyard's camera distorts their form and movement, increasing the shamanic atmosphere of the scene.

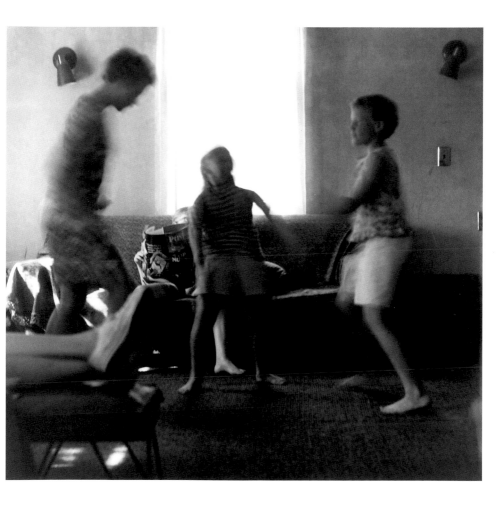

Untitled (Melissa, Madelyn and Christopher on the fourth of July), c.1967–8. In the late 1960s the family made a fourth of July visit to photographer Walt Lowe, whom Meatyard had known since the 1950s through the Lexington Camera Club. It was the middle of the Vietnam War, a time when the flag represented unreasonable US aggression and thousands of American deaths, as well as patriotic pride and a resilient democracy. Lending the icon both positive and negative connotations, Meatyard found it an enduring subject. In the Lowes' Louisville yard, members of the Meatyard family as well as Lowe's parents posed among the lawn furniture holding flimsy flags mounted on sticks. They also wandered into a decaying neighbourhood where they found the right backdrop for a homage to American industry and domestic harmony.

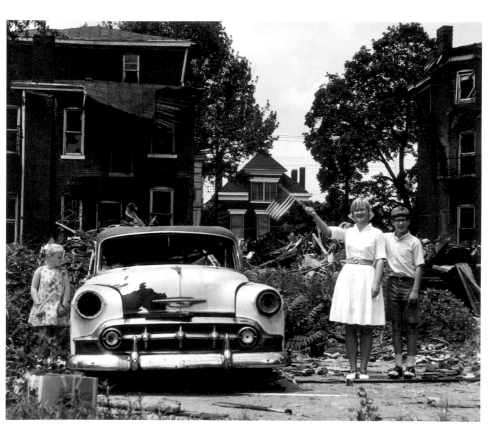

Renitent Nature, c.1968. With the help of multiple exposures, Meatyard seems to be defying his own title. If nature is reluctant to let this little girl enter its realm, he will dress her in flowers and, through photography, cause her to dissolve into the woodland surroundings. Two paintings by Magritte bear comparison with this photograph. One is the pastoral *Ready-Made Bouquet* (1957) in which Magritte himself borrowed from the Renaissance artist Sandro Botticelli, painting Flora, the goddess of flowers, on the back of a bowler-hatted man staring into the forest. The other is *Blank Signature* (1965), in which a female equestrian figure becomes part of the forest through which she rides. Meatyard also knew the work of the Russian artist Pavel Tchelitchew whose painting *Hide and Seek* (1940–42) presents transparent children in order to expose the life forces being destroyed by the Second World War.

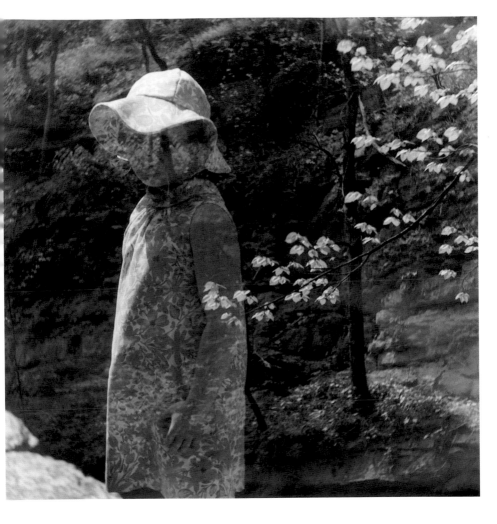

Untitled (Melissa in silhouette with rubber chicken, umbrella and water pump), c.1968. James Baker Hall was one of several poets whom Meatyard got to know in the 1960s. Also a filmmaker, he enlisted friends and their children as actors. Meatyard's daughter took part in one film and her father accompanied them to the shoot location, a training tower for firefighters near McConnel Springs, Kentucky. Little can be seen of Melissa's costume, but the profile of her figure at the left side of the window frame is a strange element in a still life that combines Surrealist iconography (the umbrella and dead bird) and anonymous rural sculpture (an iron water pump). This unlikely, silhouetted ensemble might be read as a grotesque face composed of incongruous elements all exposed to light at the same moment.

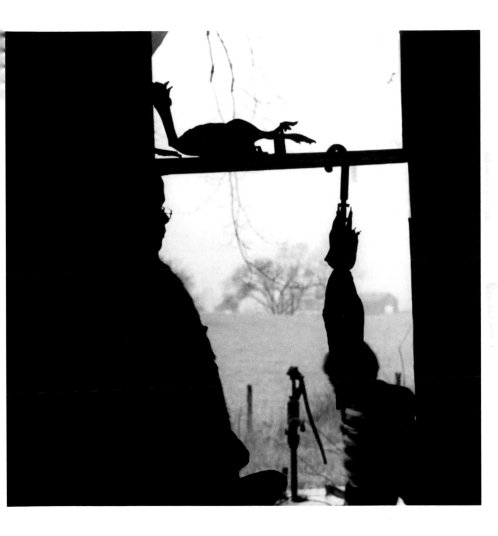

Untitled (Melissa and Madelyn in white hats and masks framing a broken window), c.1968–9. Ben Shahn's painting *Peter and the Wolf* (1943) must have lodged in Meatyard's unconscious. Shahn's composition presents two boys, one in light-coloured clothes and new white sneakers (Peter), the other in dark sweater and knee pants (the Wolf) facing each other in front of an expanse of barren trees. They wear cheap Halloween masks. Meatyard's models are his daughter (wearing tennis shoes) and his wife (in the wolf's position on the right). They each wear grotesque masks and white floppy hats. The two female figures, shown facing away from each other, inhabit a ramshackle house. A large bush separates them, threatening to invade their space through a ruined window. The intended theme is uncertain, but may well be a contentious mother-daughter relationship.

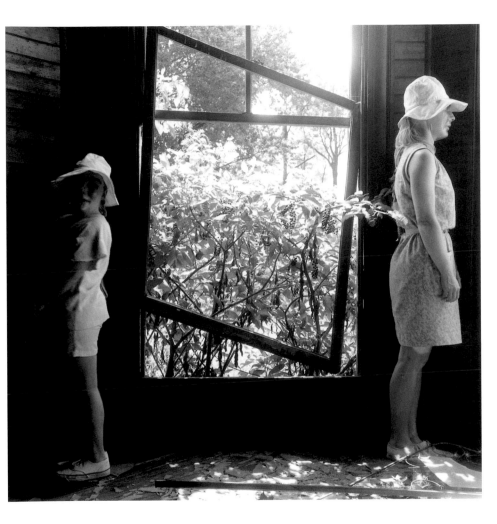

Untitled (Madelyn and Melissa wearing masks in dilapidated interior), 1968–9. Here the photographer's models seem to have borrowed poses from the subjects of Balthus' painting *The Living Room* (1942) in which two schoolgirls pose in a comfortable room, one sleeping on the couch with her left arm outstretched, the other on the floor bending awkwardly over a book. This tableau contains more action but is no less enigmatic than Balthus' mysterious picture. The villainous male mask that Meatyard's daughter wears contributes an element of androgyny that is echoed by the masculine profile of the parallel character in Balthus' work. Perhaps Meatyard's scene of implied violence between masked creatures in a rotting interior is the daydream of Balthus' napping bourgeois beauty.

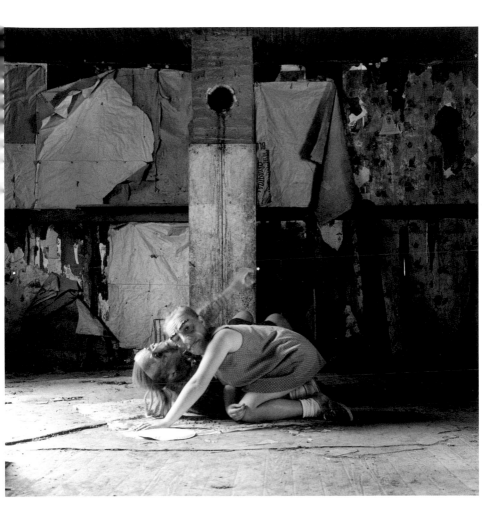

Untitled (Guy Mendes in three roles, multiple exposure), c.1968–70. Kentucky place names motivated Meatyard. He studied the county road maps until he located a Cicero, Great Crossing, Sparrow or Spears and went to see what was there, and whether the place and its name would inspire him. On this particular day, he chose Shoulderblade, southeast of Lexington. Mendes, a young Lexington poet/ photographer, became the actor in a one-man drama that Meatyard decided to stage in a long-neglected residence in that vicinity. Exposing his film as Mendes moved from character to character, Meatyard improvised a small tragedy that appears to involve three characters: a sick, dead or wounded man on the bed, a grieving friend or relative, and an ethereal figure watching by the window. The latter, an insubstantial form vapourized by the strong sunlight, seems to have the role of an impatient angel.

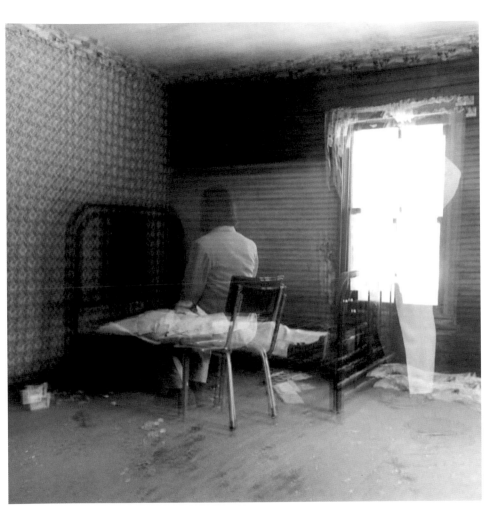

Untitled (Motion-Sound study, landscape), c.1970–71. Meatyard searched continually for a non-objective art that would be wordless poetry, spontaneous music without sound. The 'Motion-Sound' pictures of his later years brought Meatyard's passion for music and, paradoxically, the silence of Zen Buddhism together in photography. In creating the series, from which this image comes, he focused the camera on a natural scene (or one containing plain rural architecture) and then moved it slightly. The result of this action is an image that suggests sound while abstracting natural forms. The landscapes of the 'Motion-Sound' series are in stark contrast to the evocative, more traditional views of the Red River Gorge that Meatyard was executing during the same years.

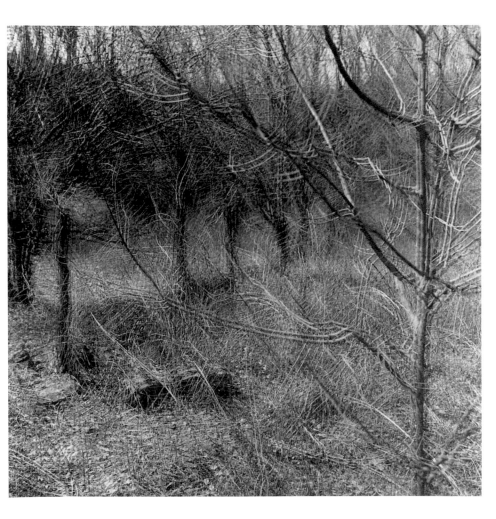

Lucybelle Crater and Close Friend Lucybelle Crater in the Grape Arbor, 1971. This photograph was taken on the Meatyards' twenty-fifth wedding anniversary, 3 July 1971. Meatyard had begun this series after being diagnosed with terminal cancer in 1970 – he died less than a year after the anniversary picture was made – and the sixty-four images were published posthumously as *The Family Album of Lucybelle Crater* (1974). The publication opens with an encyclopedia definition of 'mask'. However, in the final plate shown here, Madelyn and Gene wear more than masks as disguises. Madelyn is dressed in Gene's clothes and Gene in her skirt and blouse. He has on the witch-like mask she has worn throughout the series. He bends towards her as if to bestow a kiss or, like the Virgin Mary's friend St. Anne, to tell her what the future holds.

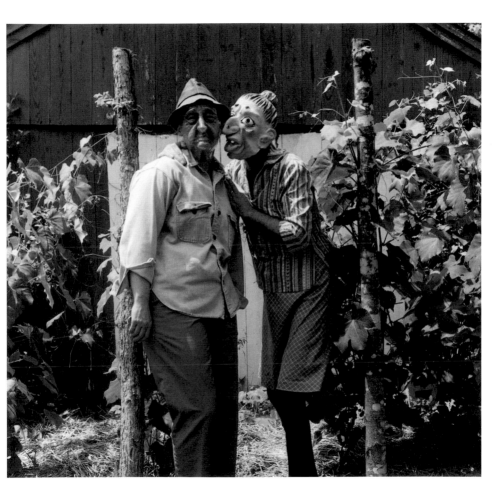

1925 Born 15 May in Normal, Illinois, the first of two children.

1943–1944 Graduates from Illinois State University, Normal. Enters the navy and enrols in the pre-dentistry programme at Williams College.

1946 Released from the navy. Marries Madelyn McKinney in Normal on 3 July. Moves to Chicago to work as optician's apprentice.

1947–1949 Returns to Bloomington. Licensed as an optician, he finds work at Gailey Eye Clinic. He and Madelyn live with his parents.

1950 Takes a position as optician with the firm of Tinder-Krauss-Tinder in Lexington, Kentucky. First son, Michael, is born. Buys 35mm camera to photograph his new child.

1954 Joins Lexington Camera Club and is taught photography by Van Deren Coke. Also joins the Photographic Society of America and begins submitting prints to national exhibitions. Acquires a second-hand Leica.

1955 Works on two series, photographing headstones in the historic Lexington cemetery and documenting the Georgetown Street neighbourhood with Coke. Second son, Christopher, is born.

1956 Work included in 'Creative Photography' exhibition, University of Kentucky. Participates in workshop at University of Indiana, Bloomington, taught by Minor White, Aaron Siskind and Henry Holmes Smith. Meets Cranston Ritchie, who will be a close friend and inspiring model for the next five years.

1957 Exhibits 'Georgetown Street' series, created with Coke, at Roy DeCarava's A Photographer's Place, New York. Begins abstraction experiments – photographing details of ice formations, rock, glass and walls. Makes paintings to be photographed and begins recording reflections of light on water.

1958 Continues experiments in abstract imagery with the 'No-focus' series and 'Zen Twigs' series.

1959 Included in the Museum of Modern Art group show 'Sense of Abstraction'. Solo show held at Tulane University, New Orleans. Daughter, Melissa, is born.

1960–1961 Meets the poet Jonathan Williams. His work is included in group exhibitions at University of Illinois, Arizona State University and George Eastman House. Solo show at University of Florida, Gainesville. Suffers a heart attack and cannot work for six months.

1962 Solo exhibition at Carl Siembab Gallery, Boston.

1963 Meets University of Kentucky English Professor Guy Davenport.

1965–1966 Introduced to Lexington poets Wendell Berry, James Baker Hall and Jonathan Greene, all of whom provide inspiration and support until his death. Solo show at the University of New Mexico, Albuquerque

1967 Opens his own optician's business. Meets Thomas Merton, who will become a close friend and mentor. Begins attempts at 'Motion-Sound' pictures. Collaborates with Wendell Berry to document and interpret the Red River Gorge area of Kentucky.

1968 Death of Merton on trip to Asia. Organizes the first of three large survey exhibitions to bring together the best photography being produced at American colleges. Around this time, he begins work on 'White Hat' and 'Lucybelle Crater' narrative series.

1970 The Institute of Design, Chicago, exhibits selections from 'Lucybelle Crater' series. Learns he has terminal cancer.

1971 Solo show at the School of the Art Institute of Chicago Gallery. Publishes *The Unforeseen Wilderness* with text by Wendell Berry.

1972 Dies at home on 7 May. Ten solo exhibitions mounted from Santa Ana, California, to Elmira, New York.

1974 *The Family Album of Lucybelle Crater*, selected and sequenced before his death, is brought out by Jonathan Williams.

Photography is the visual medium of the modern world. As a means of recording, and as an art form in its own right, it pervades our lives and shapes our perceptions.

55 is a new series of beautifully produced, pocket-sized books that acknowledge and celebrate all styles and all aspects of photography.

Just as Penguin books found a new market for fiction in the 1930s, so, at the start of a new century, Phaidon **55**s, accessible to everyone, will reach a new, visually aware contemporary audience. Each volume of 128 pages focuses on the life's work of an individual master and contains an informative introduction and 55 key works accompanied by extended captions.

As part of an ongoing program, each **55** offers a story of modern life.

Ralph Eugene Meatyard (1925–72) was a visionary photographic artist whose work was heavily influenced by his passion for literature and fascination with the past. His symbolic dramas, set in ordinary, often abandoned places and enacted mostly by his own family, seem to embody a belief that revelation does not depend on sight.

Judith Keller is associate curator of photographs at the J. Paul Getty Museum. She has published books on Walker Evans, Doris Ulmann and Andy Warhol, and has organized exhibitions on the work of Paul Strand, August Sander, Alexander Rodchenko and William Eggleston.

Phaidon Press Limited
Regent's Wharf
All Saints Street
London N1 9PA

Phaidon Press Inc.
180 Varick Street
New York NY 10014

www.phaidon.com

First published 2002
©2002 Phaidon Press Limited

ISBN 0 7148 4112 9

Designed by Julia Hasting
Printed in Hong Kong

Photographs © Ralph Eugene Meatyard Estate